You're Funny for A...

THE ILLUSTRATED GUIDE TO
Trans Comedians, Non-Binary
Comics, & Funny Women
IN THE COMEDY SCENE
BY SOPHIA ZARDERS

Written and illustrated by Sophia Zarders
SophiaZarders.com / @SophiaZarders

ISBN 978-1-945509-99-5
First Printing, November 2022
Printed in China

Published by:
Silver Sprocket
1018 Valencia St, San Francisco, CA 94110, USA
www.silversprocket.net

Avi Ehrlich - Publisher
Josh PM - General Manager
Ari Yarwood - Managing Editor
Carina Taylor - Production Designer
Daniel Zhou - Shop Rat
Raul Higuera-Cortez - Big Head Bandit
Sarah Maloney - Shop Cat
Sol Cintron - Fruit Bat

This book collects information about real people. Though we've made every
effort to ensure that the included information is accurate, mistakes can happen.
Please let us know if anything needs correcting so we can update it for future
editions of this book and do what we can to make it right.

Comedy has always been an influential force in my creative endeavors, even as a child reveling in the campy goodness of *Pee Wee's Playhouse* or renting VHS tapes of *In Living Color* from Blockbuster. Soon I discovered the magic of *Best in Show*, which introduced me to some of my favorite women performers and influenced my taste in comedy. In my early twenties, I started going to live shows in Los Angeles to see specific comedians who I recognized from my favorite TV shows, totally oblivious to the fact that so many of them started in sketch, improv, and stand-up. I would drive sometimes two hours from Long Beach to UCB Franklin, the Satellite, Lyric Hyperion, and other local venues to see the magic that brought me back time and time again.

Over the years, I've found myself gravitating toward performers who have forged a path for themselves in entertainment, comment on and critique the mainstream, and are bold in their unique approaches. Comedy is a powerful tool for survival, and frankly, those of us in marginalized communities are just *funnier*. As popular, wealthy, and out of touch comedians attack our most vulnerable minorities in the name of "free speech," it's important to note that they feel threatened by the infinitely more talented women, trans, and non-binary comics coming for their gigs.

This book began as a self-published passion project in 2018. I needed a way to showcase all my favorite comedians in the best way I knew how, through zines! One zine led to another and now you're reading the introduction to my first book, published by the lovely team at Silver Sprocket. Please support the incredible performers in this book! I can guarantee your new comedy obsession is illustrated on these pages.

I'd like to thank my parents Mitchell & Kerry for introducing comedy into my life, and my friends for enthusiastically coming with me to shows and encouraging me to make this book.

– Sophia Zarders

Michelle Buteau

MICHELLE BUTEAU (she/her) is a comedian, actor, and television personality based in New York. She grew up in New Jersey and studied journalism at Florida International University before pursuing stand-up comedy. In 2018, she created and hosted the podcast *Late Night Whenever!*, which later became a popular web series. She has appeared on *Key & Peele, 2 Dope Queens,* and in the romantic comedies *Isn't It Romantic, Marry Me,* and *Always Be My Maybe*. She stars in the series *First Wives Club* and hosts the reality competition show *The Circle,* and co-hosts the podcast *#Adulting* with comedian Jordan Carlos. In 2020, she wrote a book of essays named *Survival of the Thickest* and released her stand-up special *Michelle Buteau: Welcome to Buteaupia,* which won a Critics Choice TV Award in 2021.

STAFF RECOMMENDATION:
Welcome to Buteaupia was one of my favorite specials from 2020. Michelle is absolutely charming as she jokes about marrying a Dutch man, raising twins, and being on set with Jennifer Lopez.

Ali Wong

ALI WONG (she/her) is a stand-up comedian, writer, and actor based in Los Angeles. She was raised in San Francisco, graduated with a BA in Asian American studies from UCLA, and studied as a Fulbright scholar in Vietnam. She moved to New York to pursue comedy and was named one of *Variety*'s "10 Comics to Watch" in 2012. She wrote for the sitcom *Fresh Off the Boat* and co-wrote and starred in the romantic comedy, *Always Be My Maybe*. She acted in *Birds of Prey*, *Black Box*, *American Housewife*, and the upcoming series *Paper Girls*, and has voice acted for *Tuca & Bertie* and *Big Mouth*. In 2019, she wrote her autobiography *Dear Girls: Intimate Tales, Untold Secrets and Advice for Living Your Best Life* and was named one of *Time*'s "100 Most Influential People" in 2020. Ali has released two critically acclaimed specials, *Baby Cobra* and *Hard Knock Wife*, and her new special, *Don Wong*, debuted on Netflix in 2022.

STAFF RECOMMENDATION:

Ali's signature pull-no-punches humor is on full display in *Baby Cobra*. This special was her star-making moment and catapulted her to household recognition. It's hilarious, but maybe don't watch it with the whole family!

Danielle Perez

DANIELLE PEREZ (she/her)
is a comedian, actor, and writer based in Los
Angeles. She has performed at numerous
comedy festivals, including the Brooklyn
Comedy Festival, SF Sketchfest, and was
selected for the New Faces of Comedy
showcase for Just for Laughs in 2021.
She was featured in the CBS Diversity
Sketch Comedy Showcase in 2020 and
has performed on *Jimmy Kimmel Live* and
A Little Late with Lily Singh. She hosted
episodes of MTV's *Decoded* web series
and has appeared on *Special* and *Curb Your
Enthusiasm.* In 2021, Danielle was featured
in *Vulture*'s "Comedians You Should and
Will Know." She hosts the monthly stand-
up shows *Gentrification* in Highland Park
and *Extra* at the Silverlake Lounge. She also
appears in season two of *Russian Doll* on
Netflix.

STAFF RECOMMENDATION:
Danielle's standup set for Just For Laughs
2021 is dangerously funny and not for the
faint for heart. She jokes candidly about
tough subjects with a delightful demeanor.

Marcella Arguello

MARCELLA ARGUELLO (she/her) is a comedian and actor based in Los Angeles. She has performed at the San Francisco Comedy Festival, Riot LA Comedy Fest, and many other festivals. She has appeared on *Corporate*, *Night Train with Wyatt Cenac*, and *Sarah Cooper: Everything's Fine*. She hosts the digital series *The Cache* on Tubi and co-hosts the podcast *The Scroll Down* with comedian Nicole Thurman. In 2019, Marcella released her debut comedy album *The Woke Bully* and currently hosts the monthly show *Women Crush Wednesdays* at the Hollywood Improv.

STAFF RECOMMENDATION:
Marcella's album *The Woke Bully* is laugh-out-loud funny and and I highly recommend seeing her at one of her upcoming live shows.

Sandy Honig

SANDY HONIG (she/her) is a comedian, writer, actor, filmmaker, and photographer based in Los Angeles. She graduated from NYU with a photography degree and started performing comedy in the local scene. She is a constant collaborator with comedian Peter Smith, and together they co-host the live shows *Bongo Hour* and *PIG* at the Slipper Room. She has organized several fundraisers for LA-based leftist organizations and mutual aid relief. Sandy has directed numerous comedic shorts, including "No Respect" which premiered at Sundance in 2021. She co-created *Three Busy Debras*, a sketch group turned television show with comedians Mitra Jouhari and Alyssa Stonoha.

STAFF RECOMMENDATION:
Sandy's videos "Left of Centre" and "Three White Feminists" never fail to make me laugh out loud. For nonsensical, hilarious goodness, watch *Three Busy Debras* on Adult Swim and HBO Max!

Peter Smith

PETER SMITH (they/them) is an actor, comedian, and musician based in New York. Their comedy flows between performance art, theater, and stand-up. They performed as Princess Diana in an experimental solo show at Ars Nova and starred in the musical *XY* at the Village Theater. They were profiled for *PAPER*'s "This Generation of Comedy is Queer" and by *The New York Times* in 2020. They appeared in *Three Busy Debras*, *Girls5Eva*, *Alternatino*, the romcom *Fire Island*, and their impersonation of Annette Bening can be seen in the Comedy Central series *Up Next*. Peter swooned audiences by singing "God Only Knows" in the Hulu series, *Shrill*, and starred in the short film *Long Term Delivery*. They co-host live shows *Bongo Hour* and *PIG* with Sandy Honig at the Slipper Room, and virtual fundraisers for DSA-LA and other leftist causes.

STAFF RECOMMENDATION:
Peter's impersonation of beloved actor Annette Bening is hilarious in Comedy Central's *Up Next*. Their performance of "God Only Knows" by The Beach Boys is also one of my favorite moments from the sweet comedy *Shrill*.

Ana Fabrega

ANA FABREGA (she/her) is a comedian and actor based in New York. She grew up in Scottsdale, Arizona and worked in finance before pursuing stand-up comedy in New York City. She was featured as a Just for Laughs "New Face" in 2017 and "Best New Up-and-Coming Comedians to Watch" by *Vulture*. She has appeared on *At Home with Amy Sedaris*, *High Maintenance*, *The Special Without Brett Davis*, and *The Chris Gethard Show*. She co-created, co-wrote, and currently stars in the HBO series *Los Espookys*, and she's been profiled by *The Cut*, *Vulture*, and *NPR*, and named one of *Vogue's* "15 Rising Stars Poised to Dominate 2022." Ana currently co-hosts *Not Dead Yet* with River Ramirez and Amy Zimmer at Union Hall.

STAFF RECOMMENDATION:

Ana is absolutely genius as her awkwardly hilarious character, Tati, on *Los Espookys*. Always juggling between (really) odd jobs and the guinea pig for her friend's antics, Tati is a perfect personification of Ana's out-of-left-field humor.

Spike Einbinder

SPIKE EINBINDER (they/them) is an actor and comedian based in New York. They typically perform as chaotic characters combining drag and performance art, including the swamp comedian Candy Dish and the devilish The Red Guy. They were featured at the Pretty Major comedy show, produced by *Vulture*, and they currently co-host the live show *Together At Last* with Amy Zimmer at Union Hall. Spike has appeared on HBO's *Los Espookys*, *Search Party*, *The Chris Gethard Show*, *High Maintenance*, and *The Special Without Brett Davis*. They were profiled *PAPER*'s "This Generation of Comedy is Queer" and by *The New York Times* in 2020.

STAFF RECOMMENDATION:

Many of Spike's laugh-out-loud characters are on *The Special Without Brett Davis*, but my personal favorite is Todd, a twenty-something bro from Modesto who's auditioning for a reality show.

Naomi Ekperigin

NAOMI EKPERIGIN (she/her) is an actor, comedian, writer and podcast host based in Los Angeles. She grew up in Harlem and began pursuing comedy as a student at Wesleyan University. After working at an art magazine, she joined the writing staff for *Broad City* and was nominated for a Writers Guild of America Award in 2015. She has also written for numerous comedy series, including *Difficult People*, *Totally Biased with W. Kamau Bell*, *Great News*, and *Mrs. Fletcher*. Her first half-hour stand-up special premiered on Comedy Central and she performed on *Late Night with Seth Meyers* in 2016. Her latest special premiered on the Netflix series *The Standups* in 2022. She currently stars in *Mythic Quest* and does voice acting for *Tuca & Bertie* and *Central Park*. Naomi hosts the popular relationship podcast *Couples Therapy* with her husband, Andy Beckerman, and *I Love a Lifetime Movie* with Megan Gailey.

STAFF RECOMMENDATION:
Naomi's half-hour special for *The Standups* is an absolute joy. She talks about the magic of Palm Springs, growing up as a precocious child, and becoming a dog person.

Megan Gailey

MEGAN GAILEY (she/her) is a stand-up comedian and podcast host based in Los Angeles. Megan has performed at numerous comedy festivals across the country, including the "New Faces" showcase at Just For Laughs, Clusterfest, SXSW, and Bridgetown Comedy Festival. Her stand-up sets have been televised on Comedy Central, *The Tonight Show*, and *Conan*. In 2019, she released her debut album, *My Dad Paid for This*. She currently co-hosts the podcast *I Love a Lifetime Movie* with Naomi Ekperigin, and *Go Hoarse: A Colts 'Hard Knocks' Breakdown Podcast* with Aaron Edwards. In 2021, she was nominated for a Writers Guild Award for *Pause with Sam Jay*.

STAFF RECOMMENDATION:

Megan's super funny set for Just For Laughs covers getting kicked out of a sorority, being self-aware of her white womanhood, and the strange things her grandmother tells her. If you're in Los Angeles, watch her perform live at the Silverlake Lounge, the Virgil, and other popular comedy venues!

Dee Luu

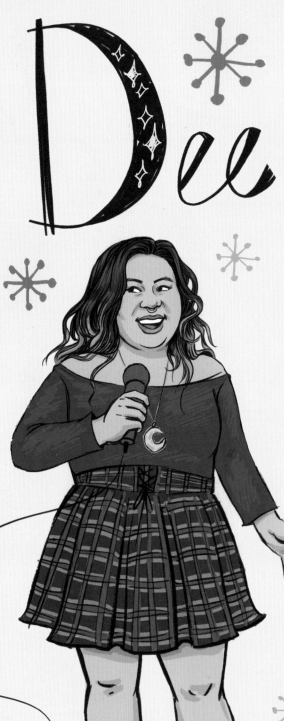

DEE LUU (she/they) is a comedian, singer, writer, and performer based in New York. They grew up in Dallas, Texas and studied musical theater at the University of Central Oklahoma. She has written for *Reductress* and *Awf Magazine*, and has graced the stage for numerous theater productions across the country. They hosted the live show *Christian's Best Friend Race* and currently perform with the sketch groups Queer Window and Overstep Comedy. In 2021, Dee created and starred in *Trans Moses*, a live show at Ars Nova exploring their intersecting identities.

STAFF RECOMMENDATION:
Follow Dee's TikTok for clips of her incredible singing and go see her perform live in Brooklyn!

Edson Montenegro

EDSON MONTENEGRO (they/them) is a comedian and writer based in New York. They grew up in Los Angeles and studied at Northwestern before pivoting to comedy. They currently host the monthly live show *Tea Before Bed* and perform in the sketch shows *Queer Window* and *Dark with a Chance of Stupid*. Edson is also a member of the Brooklyn Comedy Collective.

STAFF RECOMMENDATION:
Check out Edson's super funny TikToks where they joke about sex, dating, and pop culture!

Cara Washington

CARA WASHINGTON (they/she) is a writer, actor and comedian based in New York. They grew up in New Jersey and moved to the Big Apple to pursue comedy. She trained in screenwriting at UCB where she received a diversity scholarship in 2019. They were selected as a quarterfinalist in the 2019 Nicholl Screenwriting Fellowship and a semi-finalist in the 2019 Atlanta Film Festival Screenplay Competition. Cara is currently a member of Story Pirates NYC and the Writers' Assistant for *The Late Show with Stephen Colbert.*

STAFF RECOMMENDATION:
If you live in New York, go see Cara perform live at a local comedy show around Brooklyn!

Lili Michelle Koohestani

LILI MICHELLE KOOHESTANI (she/her) is a stand-up comedian based in New York, originally from Toronto. Her stand-up explores dating, relationships, and pop culture. She was named one of The New York Comedy Festival's 2021 "Comics to Watch" and named one of *Vulture*'s "Best Up and Coming Stand-Ups." She is a writer for arts and culture online magazine, *Document Journal*, and hosted the podcast *Sad Tits*. She co-hosts the live shows *Good Show* at Union Hall and *Peaches and Cream* at Central Organic.

STAFF RECOMMENDATION:
If you're in New York, definitely catch Lili at her live shows *Peaches and Cream* or *Good Show*. If you can't make it to the Big Apple, her twitter, @lilsmichelle, is a must-follow for comedy fans.

Nicole Byer

NICOLE BYER (she/her) is a comedian, actor, and author based in Los Angeles. With a background in theater, she began pursuing improv comedy at the Upright Citizens Brigade in New York. She hosts the popular sex and relationship podcast, *Why Won't You Date Me?*, and co-hosts numerous podcasts including *Best Friends* with Sasheer Zamata and *Newcomers* with Lauren Lapkus. Nicole co-hosts ABC's *Wipeout* with John Cena and is the host of Netflix's fan-favorite series, *Nailed It*, which landed her Emmy nominations for Best Reality Competition Host in 2020 and 2021. She has appeared on *Girl Code, Brooklyn Nine-Nine, The Good Place*, and *A Black Lady Sketch Show*, and is a frequent guest judge on *Rupaul's Drag Race*. She has recently published a book, released her hour-long special *Nicole Byer: BBW (Big Beautiful Weirdo)* on Netflix, and currently stars in the ABC sitcom, *Grand Crew*.

STAFF RECOMMENDATION:

Nicole's long-standing podcast *Why Won't You Date Me?* is an absolute treat! She consistently interviews entertaining comedians, matchmakers, sex workers, drag queens, and more. A few of my favorite episodes feature Shalita Grant, Solomon Georgio, and Amber Ruffin.

Bob the Drag Queen

BOB THE DRAG QUEEN (he/she) is a stand-up comedian, drag performer, and actor based in Los Angeles. He grew up in Clayton County, Georgia, studied theater at Columbus State University, and moved to New York to pursue acting. In 2009, she began performing stand-up comedy in drag and created her current persona in 2013. He was crowned the winner of *RuPaul's Drag Race* season 8 and has performed around the world ever since. In 2017, she released her first standup special *Suspiciously Large Woman* and her second special *Bob the Drag Queen: Crazy Black Lady* aired in 2020. He co-founded the activist event "Black Queer Town Hall" and performed in the live tour *Nubia*, which showcased Black drag queens. She currently co-hosts the HBO docuseries *We're Here* and the podcast *Sibling Rivalry* with Monét X Change.

STAFF RECOMMENDATION:

As a passionate *Drag Race* fan, I can't help but recommend Bob's incredible run on season 8. *Sibling Rivalry* is also one of my essential podcasts but I'm also a big fan of *We're Here*. I guess I'll recommend everything!

Nori Reed

NORI REED (she/her) is a stand-up comedian, writer, and actor based in Los Angeles. She made a name for herself in the East Bay comedy scene and was named "Oakland's Next Great Comedian" by *SF Weekly* in 2019. She opened for Amy Poehler at Comedy Central's Clusterfest and Maria Bamford at SF Sketchfest, and has performed at Outside Lands Music and Arts Festival and All Jane Comedy Festival. Nori was named in "Comedians You Should and Will Know in 2021" by *Vulture*, and featured in the HBO Max Queer Comedy Showcase. She is a writer for the comedy podcast, *Hot White Heist,* and the upcoming *That's So Raven* reboot, *Raven's Home.* She currently hosts the monthly live show, *Icons Only*, with Maddie Connors and Christine Medrano at the Silverlake Lounge.

STAFF RECOMMENDATION:

Nori's standup set for HBO Max's Queer Comedy Showcase is a fantastic introduction to her smart comedic style. She talks about her lived experience as a mixed, trans person through quippy, hilarious jokes. Her Twitter account, @realnorireed, is a must-follow too!

Maddie Connors

MADDIE CONNORS (she/her) is a writer and comedian based in Los Angeles. She has written articles for numerous publications, including *The New York Times, Reductress, Vanity Fair*, and *Teen Vogue*. She currently co-hosts the live show *Icons Only* with Nori Reed and Christine Medrano. In 2021, she hosted the virtual show *Border Aid* which fundraised for Al Otro Lado. Maddie also co-hosts the live show *You're Gonna Love This* with Katy Fishell at Lyric Hyperion.

STAFF RECOMMENDATION:
If you're in LA, go see Maddie perform live at the Elysian Theater, Silverlake Lounge, and other popular venues!

Ziwe Fumudoh

ZIWE FUMUDOH (she/her) is a comedian, actor, and internet personality based in New York. She is the titular host of *Ziwe* on Showtime, which originated from the web series *Baited with Ziwe*. During the pandemic, she interviewed comedians and controversial celebrities on her Instagram live, including Rose McGowan and Caroline Calloway. Ziwe has written for *Desus and Mero*, *The Onion*, *Reductress*, and *The Rundown with Robin Thede*. She was featured in the Amazon comedy special, *Yearly Departed*, and has appeared as a guest star on HBO's *Succession* and ABC's *The Bachelor*. Season two of *Ziwe* airs soon on Showtime!

STAFF RECOMMENDATION:
Ziwe's television show of the same name is absolutely ICONIC! So many of your favorite comedians, actors, and musicians are quizzed on controversial topics with absurd twists. A few of my favorite segments include "Hollywood Scramble" with Adam Pally and "Wheel of Accents" with Julio Torres.

Patti Harrison

PATTI HARRISON (she/her) is an actor, comedian, writer, and visual artist based in Los Angeles. She was named one of *Variety*'s "10 Comics to Watch" in 2019 and she was a featured comedian in the 2020 special *Yearly Departed*. She has appeared on *Search Party*, *I Think You Should Leave*, *Ziwe*, and had a recurring role on *Shrill* and *Made For Love*. She starred in the 2021 indie film *Together Together* and was nominated for an Independent Spirit Award for her performance. Patti has also voice acted for *Raya and the Last Dragon*, *Tuca & Bertie*, *The Great North*, and *Big Mouth*. She co-hosted the digital series *Unsend* with Joel Kim Booster and the podcast *A Woman's Smile* with River L. Ramirez. She will appear in the upcoming comedies *The Lost City* and *Mack & Rita*.

STAFF RECOMMENDATION:

Patti's humor is perfectly encapsulated in her set for Comedy Central, where she performs a demented pop song she wrote for Dua Lipa. Of course, I'd be remiss not to recommend her podcast *A Woman's Smile*, specifically the episode "A Woman's Smile is Sponsored."

Rachel Sennott

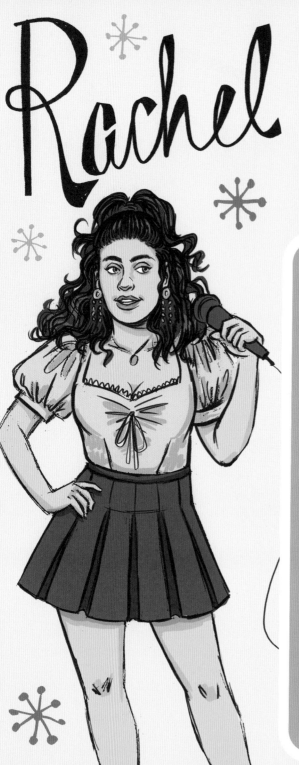

RACHEL SENNOTT (she/her) is an actor and stand-up comedian based in Los Angeles. She studied acting at NYU Tisch and began pursuing stand-up in the local alternative comedy scene. She co-hosted the live shows *Puke Fest* and *Ur Gonna Slp Rlly Well Tonight* with comedian Moss Perricone. She co-created and starred in the web series *Ayo and Rachel Are Single*, and starred in the television shows *Call Your Mother* and *High Maintenance*. In 2020, she made waves starring in *Shiva Baby*, a queer Jewish indie film directed by Emma Seligman. For her role, she was nominated for Breakthrough Actor by the Gotham Independent Film Awards and the film won the John Cassavetes Award at the Independent Spirit Awards in 2022. Rachel also stars in the horror movie *Bodies Bodies Bodies*.

STAFF RECOMMENDATION: Rachel is incredible in the surreal comedy *Shiva Baby*. She plays Danielle, an uncomfortable twenty-something who faces her mistakes while being bombarded by family members.

Ayo Edebiri

AYO EDEBIRI (she/her) is an actor, comedian, and writer based in Los Angeles. She grew up in Boston and discovered her passion for comedy while studying at NYU and interning at UCB. She performed a standup set for Comedy Central's *Up Next* and has graced the stage at Clusterfest, Dynasty Tonight, and Just for Laughs. Ayo has appeared on *The Premise*, *Dickinson*, and voice acts for *Big Mouth*, and she co-created and starred in the digital series *Ayo and Rachel Are Single*. She also appears in the teen movie *Hello, Goodbye and Everything In Between*.

STAFF RECOMMENDATION:

Ayo's stand-up set for Comedy Central is beyond funny and her super high horror story is relatable and hilarious.

River L. Ramirez

RIVER L. RAMIREZ (they/them) is a musician, comedian, actor, and visual artist based in New York. They are a multi-hyphenate artist, transcending genres and performing at MoMA PS1, Gibney, and the Baryshnikov Arts Center. They are currently a resident artist with the Vision Residency program at Ars Nova. In 2021, they released their debut EP, *The Night Time Songs*. They co-host the monthly show *Not Dead Yet* with Ana Fabrega and Amy Zimmer at C'mon Everybody, and host their live solo show *Art is Easy* on Twitch. River previously co-hosted the cult favorite podcast *A Woman's Smile* with Patti Harrison, and has appeared on *Los Espookys*, *The Special Without Brett Davis*, and *Random Acts of Flyness*. They were profiled for *PAPER's* "This Generation of Comedy is Queer."

STAFF RECOMMENDATION:
River is wild, demonic, and beyond funny in their 2019 standup set for *The Macaulay Culkin Show*. Their podcast *A Woman's Smile* is also in my pantheon of favorite podcasts EVER!

Mitra Jouhari

MITRA JOUHARI (she/her)
is a writer, comedian and actor based in Los Angeles. She has performed standup for numerous festivals, including Clusterfest, Netflix is a Joke, and SXSW. In 2017, she was nominated for a Writers Guild Award for her work on *The President Show*, and has written for *High Maintenance*, *Pod Save America*, *Miracle Workers*, and *Big Mouth*. She has appeared on *Search Party*, *The Special Without Brett Davis*, and *Friends From College*. She co-created and stars in the live show turned television series *Three Busy Debras*. Mitra is a proud leftist and has organized several fundraisers for great causes, including DSA Los Angeles and K-Town for All. She currently co-hosts the podcast *Urgent Care* with Joel Kim Booster, and hosts the monthly live show *Mitra Jouhari's Horny Little Show* at the Elysian Theater.

STAFF RECOMMENDATION:
Mitra has a fantastic and surreal standup set called "Having a Medically Bad Personality" for Comedy Central. I had the honor of seeing her live show *Fuck Hut Music School for Teens* and highly recommend the podcast that stemmed from that as well.

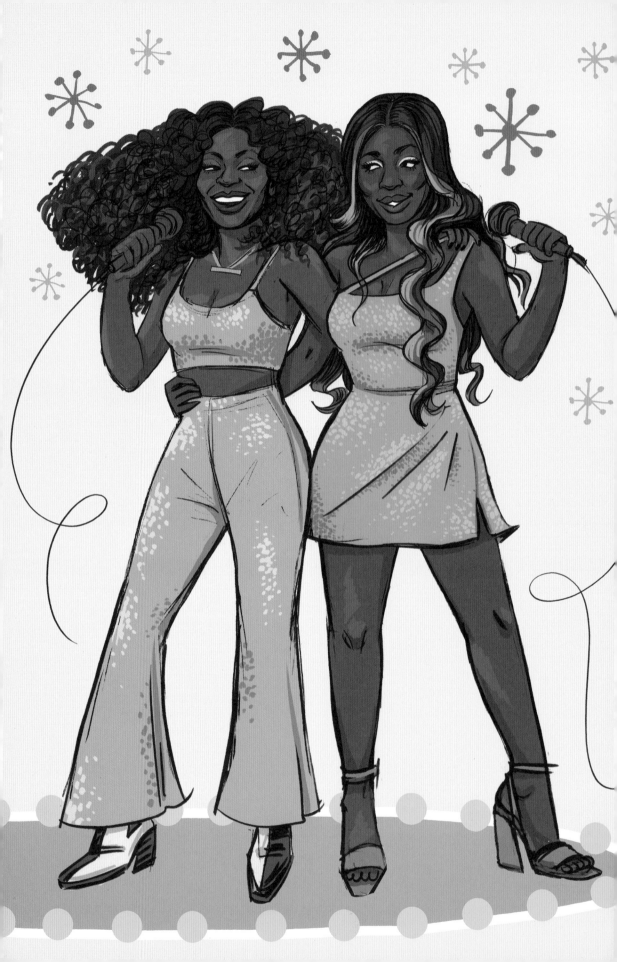

Marie Faustin & Sydnee Washington

MARIE FAUSTIN (she/her)

is a comedian and actor based in New York. She was named a 2018 "Comedian You Should Know" by *Vulture*, and she's appeared on *Broad City, Search Party*, and *High Fidelity*. She was a featured comedian in *Ilana Glazer Presents Comedy on Earth: NYC 2020-2021*, and co-hosted the live television show *Vice Live*. She has performed stand-up for Comedy Central and at Clusterfest in 2018, and she was profiled by *Time Out New York*. She currently co-hosts the podcast, *The Unofficial Expert*, and the live show *Comedy at the Knitting Factory* with Sydnee Washington.

STAFF RECOMMENDATION:

Marie has a great standup set for Comedy Central about becoming obsessed with *Law & Order: SVU*. Also, subscribe to *The Unofficial Expert* podcast on Patreon!

SYDNEE WASHINGTON (she/her)

is a comedian and actor based in Los Angeles and New York. Her one-woman show *Death of a Bottle Girl* debuted in 2018 and she is currently performing her show *How to Start a Fire*. She was featured on Comedy Central's *Up Next* showcase. She has appeared on *Broad City, Ziwe*, and *Bridesman*. During the quarantine in 2020, she hosted the popular Instagram live show *Syd Can Cook*, which invited comedians, including her roommate Karolena Theresa, to help her cook dishes. She currently co-hosts the podcast, *The Unofficial Expert*, and the live show *Comedy at the Knitting Factory* with Marie Faustin. She also hosts the podcast *Hobby Hunter*. She was profiled by *Vulture, Harper's Bazaar, W Magazine*, and *PAPER*.

STAFF RECOMMENDATION:

Sydnee's episode of *Ilana Glazer Presents: Tight Five* is beyond funny. She jokes about getting arrested at the airport and thriving in quarantine. Of course, subscribe to *The Unofficial Expert!*

Cole Escola

COLE ESCOLA (they/them) is a comedian, actor, and singer based in New York. They grew up in small-town Oregon and came up as a performer in the New York cabaret scene. They performed in Bridget Everett's acclaimed 2014 musical-comedy show *Rock Bottom*. Cole co-created and starred in the cult television show *Jeffery and Cole Casserole* with comedian Jeffery Self. They've acted in numerous fan-favorite shows, including *Difficult People, At Home with Amy Sedaris, Ziwe,* and *Search Party*. In 2017, they produced and hosted their first solo show *Help, I'm Stuck* at Joe's Pub, which became a 2020 comedy special showcasing various characters and sketches.

STAFF RECOMMENDATION:

Cole gives an amazing performance in *Search Party* as kidnapper/heir to a cinnamon bun empire, Chip Wreck. I also love their character Matthew on *Difficult People*, and highly recommend the episode "Strike Rat."

Kate Berlant

KATE BERLANT (she/her)

is a comedian and actor based in Los Angeles. She grew up in a creative household and studied acting at NYU. In 2016, she starred as an array of absurd characters inspired by the contemporary art world for *The Characters*. In collaboration with comedian John Early, she has co-created a number of surreal sketch videos, including the 2017 short film anthology *555*. She appeared in *Sorry to Bother You, Once Upon a Time in Hollywood, Search Party, The Other Two*, and the Olivia Wilde film *Don't Worry Darling*. Kate has performed on *The Tonight Show* and *Late Night with Seth Meyers*, and has voice acted for *Bojack Horseman, Summer Camp Island* and *Tuca & Bertie*. Currently, she hosts her live show *Kate Berlant: Like You've Never Seen Her* at the Elysian, and co-hosts the self help podcast *POOG* with comedian Jacqueline Novak.

STAFF RECOMMENDATION:

Kate's out-of-this-world episode of *The Characters* converted me to one of her biggest fans. Her short videos "Paris" and "How Have You Been?" with John Early also leave me in pieces every time I watch them.

Joyelle Nicole Johnson

JOYELLE NICOLE JOHNSON (she/her) is a stand-up comedian, writer, and actor based in New York. She grew up in New Jersey, studied at Boston College, and moved to Los Angeles to pursue acting. She made her television debut on *Late Night with Seth Meyers* in 2018 and has appeared on *Search Party*, *Crashing*, and *Pause with Sam Jay*. She currently co-hosts *You're Welcome, America* with comedian Adrianne Chalepah. Joyelle released her first comedy album *Yell Joy* in 2021, and her debut stand-up special *Love Joy* was nominated at the 2022 Critics Choice Awards.

STAFF RECOMMENDATION:
Joyelle's comedic style pulls no punches, even her 2021 set on *The Tonight Show*. She jokes about living in Georgia and flying with the elderly.

Adrianne Chalepah

ADRIANNE CHALEPAH (she/her) is a comedian, writer, and actor based in New Mexico. She was raised on the Kiowa/Comanche/Apache reservation, and is an enrolled member of the Kiowa and Apache Tribes of Oklahoma. While studying communications and Indigenous studies at Fort Lewis College, she began performing stand-up comedy and joined the group 49 Laughs Comedy. She co-founded Ladies of Native Comedy, a troupe of Indigenous femme comedians who have performed across the country. Her writing was included in the anthologies *Funny Girl* and *#NotYourPrincess: Voices of Native American Women.* She was selected for the 2021 Yes, And... Laughter Lab for her screenplay *Running* and appeared on the Peacock series *Rutherford Falls.* She currently co-hosts the digital series *You're Welcome, America* with comedian Joyelle Nicole Johnson.

STAFF RECOMMENDATION:
You're Welcome, America is a cathartic comedy show for any comedy fan of color. Adrianne is a charming co-host and breaks down complex social issues with witty, hilarious jokes.

Quinta Brunson

QUINTA BRUNSON (she/her) is an actor, comedian, and internet personality based in Los Angeles. She grew up in Philadelphia, studied at Temple University, and pursued comedy after taking improv classes at Second City. Her career started in self-producing online videos, most famously her series of popular videos *Girl Who Has Never Been on a Nice Date*, and then later worked at Buzzfeed. She starred in the first season of HBO's *A Black Lady Sketch Show*, and has appeared on *Miracle Workers*, *Single Parents*, and *iZombie*. She is a popular voice actor for animated series, including *Magical Girl Friendship Squad*, *Lazor Wulf*, and *Big Mouth*. In 2021, she wrote a collection of essays titled *She Memes Well*. Quinta currently stars in *Abbott Elementary*, a popular network sitcom she co-executive produces and writes for.

STAFF RECOMMENDATION:
Abbott Elementary is extremely charming, sweet, funny, and relatable. Quinta is perfect as Janine, an incessantly optimistic teacher trying to make a struggling school a better place.

Janelle James

JANELLE JAMES (she/her) is an actor, writer and stand-up comedian based in New York. She grew up on St. Thomas and began performing comedy while living in Champaign, Illinois. She has performed around the country at festivals like Clusterfest and Just for Laughs, and produced her own event, The Janelle James Comedy Festival, based in Brooklyn. Her debut special, *Black & Mild*, was released in 2017 and she was named one of *Variety's* "Top Ten Comedians to Watch in 2020." She has appeared on *Black Monday, Crashing, Corporate*, and is a main cast member on *Abbott Elementary*. Both of her stand-up specials have aired on Netflix for *The Comedy Lineup* and *The Standups*. She currently hosts the relationship podcast *You In Danger*.

STAFF RECOMMENDATION:

Janelle's 2021 half-hour special for *The Standups* is laugh-out-loud, sore abs, can-barely-breathe funny. Her dark sense of humor lends itself to jokes about parenting, Uber etiquette, and the Insurrection. Her performance as Ava the principal of *Abbott Elementary* is also iconic.

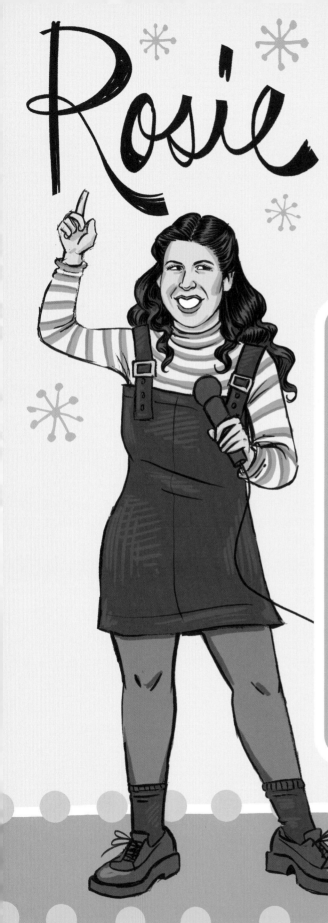

Rosie Jones

ROSIE JONES (she/her)
is a stand-up comedian, writer, and actor based in the UK. She was born in Bridlington, England and graduated from the University of Huddersfield. She started her career writing for television, including the shows *The Last Leg*, *8 Out of 10 Cats*, and Netflix's *Sex Education*. She has performed two solo shows at the Edinburgh Festival Fringe, and her 2018 set *Fifteen Minutes* was critically acclaimed. Rosie has appeared in the BBC series *Shakespeare & Hathaway* and *Casualty*, and starred in her own travel series *Trip Hazard: My Great British Adventure*. She recently wrote the children's book *The Amazing Edie Eckhart*, and has announced her upcoming sitcom titled, *Disability Benefits*.

STAFF RECOMMENDATION:
Rosie's live set at the Apollo is a perfect taste of her darkly funny sense of humor. She gives a memorable glimpse into her odd sexual fantasies.

Lolly Adefope

LOLLY ADEFOPE (she/her) is a comedian and actor based in London. She grew up in Sutton, South London and studied literature at Loughborough University where she began performing sketch comedy. In 2015, her career took off after she performed a solo show at the Edinburgh Festival Fringe. She has appeared in numerous television shows, including *This Time with Alan Partridge*, *Miracle Workers*, and *Damned*. She is a fan favorite on the popular series *Shrill* and *Ghosts*, and she appeared in *Mission Impossible: Fallout* and *The Spy Who Dumped Me*. Lolly has been a panelist on the game shows *TaskMaster*, *QI* and *Don't Ask Me Ask Britain*. She will act in the upcoming series *Girls Can't Shoot (& Other Lies)*.

STAFF RECOMMENDATION:

In *Shrill*, Lolly gives a fantastic performance as Fran, the coolest hairdresser and lesbian icon. I also recommend her segment for "Comedians Giving Lectures," which is a hilarious rundown on social media and technology.

Megan Stalter

MEGAN STALTER (she/her) is an actor and comedian based in Los Angeles. She was raised in Cleveland and moved to Chicago to pursue improv and sketch comedy. She is known for her numerous absurd and awkward characters that became popular in online videos and via social media. In 2019, she was named a "Comedian You Should and Will Know" by *New York Magazine*. She created and hosted the webseries *The Megan Stalter Show* and the podcast *Confronting Demons with Megan Stalter*. She made waves starring as an absent-minded assistant in the HBO Max comedy *Hacks*, and appeared in Kacey Musgraves' 2021 visual album, *Star-Crossed*. In 2021, she performed in the ensemble comedy special *Yearly Departed for Amazon*.

STAFF RECOMMENDATION:

Megan is a super funny scene-stealer as Kayla in the Golden Globe winning comedy *Hacks*. Her front-facing camera videos are also iconic, especially her performance as a stuffy corporation trying to appeal to LGBTQ consumers celebrating Pride.

Sarah Squirm

SARAH "SQUIRM" SHERMAN (she/her) is a comedian, visual artist and a current cast member on *Saturday Night Live*. She studied theater at Northwestern University and began making surreal, body horror-inspired comedy in Chicago. She created the live variety show *Helltrap Nightmare* and has hosted several fundraisers for Bernie Sanders, DSA LA, Nithya Raman, NOlympics LA, and Fatima Iqbal-Zubair. Sarah created the short films *Sarah Vaccine* for MeansTV and *Flayaway* for Adult Swim, as well as candy-colored gross-out gifs for Giphy.

STAFF RECOMMENDATION: Sarah's madcap humor is best witnessed live at *Helltrap Nightmare*. She's also an excellent scene-stealer during Weekend Update on *Saturday Night Live*.

Yvonne Orji

YVONNE ORJI (she/her) is an actor, author, and stand-up comedian based in Los Angeles. Born in Port Harcourt, her comedy centers her Nigerian upbringing and experiences as a first generation immigrant in Maryland. After receiving a graduate degree in public health from George Washington University, she moved to New York City to pursue comedy. She took Hollywood by storm after landing the role of Molly on HBO's *Insecure*, and has acted in numerous projects, including *Spontaneous*, *A Black Lady Sketch Show*, *Jane the Virgin*, and *Night School*. Yvonne wrote the advice book *Bamboozled by Jesus*, and is currently in development with Disney+ for an upcoming series titled, *First Gen*. In 2020, she was nominated for Outstanding Supporting Actress at the Emmys and her debut comedy special *Momma, I Made It!* premiered on HBO.

STAFF RECOMMENDATION:
I'm a huge fan of Yvonne's performance as Molly on *Insecure*, but I also absolutely love her HBO special *Momma, I Made It!* Her super funny special includes clips of Yvonne visiting her family in Nigeria and interviewing locals about her celebrity status.

Aparna Nancherla

APARNA NANCHERLA (she/her) is an actor, comedian, and writer based in New York. She was raised in Washington, D.C., studied psychology at Amherst College, and started her comedy career writing for *Totally Biased with W. Kamau Bell* and *Late Night with Seth Meyers*. Her first comedy album *Just Putting It Out There* debuted in 2016, and her first half-hour special aired in *The Stand-Ups* on Netflix in 2018. She co-created and starred in the web series *Womanhood* with comedian Jo Firestone and was showcased in the Amazon comedy ensemble special *Yearly Departed*. She has voice acted for *BoJack Horseman*, *Steven Universe*, *Bob's Burgers*, and *The Great North*. Aparna has acted in *Corporate*, *Space Force*, *Search Party*, and *Crashing*. *Variety* named her one of the "Top 10 Comics to Watch for 2016," and she has been profiled by *The New York Times*, *W Magazine* and *Vulture*.

STAFF RECOMMENDATION:

Aparna's appearance on *The Late Show with Stephen Colbert* is a fantastic dive into her comedic mind. She discusses anxiety, mental health, and being an introvert with thought-provoking and relatable jokes. Her performance as Grace, the human resources rep in Comedy Central's *Corporate*, is also a must-watch.

Roz Drezfalez

ROZ "DREZFALEZ" HERNANDEZ

(she/they) is a comedian and actor based in Los Angeles. She grew up in Grand Rapids, Michigan and began experimenting with drag after moving to Los Angeles. In 2019, they debuted the critically acclaimed and popular podcast *Ghosted!* which features interviews with comedians, entertainers, and experts about paranormal phenomena. They starred in the 2020 short film *Three Queens* and appeared in the indie movie *Moon Manor*. She has graced the stage in the drag parody productions *Mean Gays* and *Sheetle-Juice*, and regularly performs stand-up at venues around LA.

STAFF RECOMMENDATION:

Check out Roz's spooky and laugh-out-loud podcast, *Ghosted!* I recommend the episodes with Jinx Monsoon and Danielle Perez.

Atsuko Okatsuka

ATSUKO OKATSUKA (she/her) is a comedian and actor based in Los Angeles. She grew up in Japan, and lived undocumented in the United States with her mother and grandmother. She discusses her upbringing in her comedy and collaborates with her family in viral online sketches and dance videos. She co-founded the stand-up tour *Dis/orient/ed Comedy* with Jenny Yang and Yola Lu, which showcases Asian-American performers. In 2018, she debuted her first hour-long special *They Call Me Stacey* and was featured in the Hulu comedy special *Comedy InvAsian*. She has been named a "Comedian to Watch" by *Vulture* and *Time Out*, and released her debut album, *But I Control Me*, in 2020. She currently hosts the live shows *Hi, Atsuko & Friends*, and *Let's Go, Atsuko!* which is also a popular podcast.

STAFF RECOMMENDATION:
Let's Go, Atsuko! is a fantastic live show and podcast in the style of a Japanese game show. Atsuko is a hilarious host and leads a panel of comedian guests through fun and witty games. I had the joy of watching this live show at Dynasty Typewriter back in 2019, and I've been dying to see her perform again soon!

Dylan McKeever

DYLAN MCKEEVER (she/they) is a stand-up comedian and illustrator based in Los Angeles. She creates short videos and comics about astrology, plants, dating, and her lived experience as a queer trans femme artist. They host *Plant Talk*, an Instagram show where their friends impersonate different plants in their apartment. She was featured in the webseries *The Library*, showcasing a variety of queer and trans panelists. Dylan makes hilarious and relatable videos and gifs for social media, and has performed at the live shows *Weirdo Night*, *Hey Chica*, and *Cult Comedy*.

STAFF RECOMMENDATION:

Plant Talk is a great introduction to the sweet, funny, and absurd world of Dylan's comedy. Each episode features a different performer, artist, educator, etc to voice their many, many plants.

Sophie Santos

SOPHIE SANTOS (she/her) is a stand-up comedian and author based in New York. She performed at Edinburgh Fringe Festival, Sketchfest, and The Kennedy Center. She created and hosts the live show The Lesbian Agenda, and voice acts for Hot White Heist and Hit Job. She has written for Bravo and MTV, and performed on *Jimmy Kimmel Live!* Her critically acclaimed memoir, *The One You Want to Marry (And Other Identities I've Had)*, is a bestselling book on Amazon.

STAFF RECOMMENDATION:
The One You Want to Marry is essential reading for queer comedy fans! Sophie shares awkward, relatable, and funny memories from her lived experience as a mixed Filipinx lesbian.

Robby Hoffman

ROBBY HOFFMAN (she/her) is a stand-up comedian, actor, and writer based in Toronto. She grew up in a large Hasidic Jewish family in New York and Montreal, and studied accounting at McGill University. While pursuing her MBA, she pivoted to comedy and moved to New York. She wrote for *The Chris Gethard Show*, *Baroness Von Sketch Show*, and *Workin' Moms* on CBC. In 2019, she won a Daytime Emmy for her work on the children's show *Odd Squad* and filmed her first stand-up special, *I'm Nervous*, in Toronto. Robby was named one of *Vulture*'s "The Comedians You Should and Will Know in 2020." Her upcoming A24 produced project *Rivkah* is currently in development at Showtime.

STAFF RECOMMENDATION:
Robby's standup set for *Don't Tell Comedy* is beyond funny and tackles her upbringing as one of TEN children in a working class, Hasidic family in Crown Heights.

Jenny Yang

JENNY YANG (she/her)
is a comedian, writer, and actor based in Los Angeles. She studied political science at Swarthmore College and after graduation became a labor activist in Los Angeles. She started performing stand-up comedy and created a nationwide show series for Asian-American performers called Disoriented Comedy in 2012. This grew into a comedy festival called the Comedy Comedy Festival: A Comedy Festival, running from 2014-2018. She was selected for *Variety*'s "10 Comics to Watch" and *Vulture*'s "Comedians You Should and Will Know in 2020." Her essay, "I'm An Asian American Stand-Up Comedian. What If I Could Just Be A Stand-Up Comedian?" was published by *Elle Magazine* in 2018. Jenny wrote for *Last Man Standing* and *Busy Tonight*, and was selected as a writing mentor for the 5050 by 2020 Disruptors Fellowship. She currently hosts the podcast *Going Through It* and a virtual stand-up show and Black Lives Matter fundraiser called *Comedy Crossing*.

STAFF RECOMMENDATION:
During Andrew Yang's presidential run in 2020, Jenny created the video "More American," satirizing his nationalistic, ignorant platform. Her uncomfortable interactions with the community are a great balance of comedy and social commentary.

Jes Tom

JES TOM (they/them) is a writer, comedian, and actor based in New York, originally from San Francisco. They were featured in *TimeOut New York*'s Breakout Artist Comedy Series in 2019, and profiled by *Splitsider*, *Vulture*, *Vice*, and *Forbes*. In 2016, they produced their debut comedy special, *COLD BREW*, and were later selected as a Standup NBC semifinalist in 2018. They've written for *Reductress*, *Them*, *Shondaland*, and starred in the short independent films *Anatomy of an Orchard* and *Soojung Dreams of Fiji*. Jes was named a "Comedian You Should and Will Know in 2021" by *Vulture*, and they are currently performing their new stand-up special *Less Lonely* at Union Hall. They co-host *The Favorites* podcast with comedian Tessa Skara.

STAFF RECOMMENDATION:

Jes graced the stage at the "New Faces of Comedy" showcase for Just For Laughs in 2021. Their hilarious standup set covers transitioning, non-monogamy, and making a good impression with a significant other's parents.

Ashley Ray

ASHLEY RAY HARRIS (she/her) is a writer, stand-up comedian, and actor based in Los Angeles. She grew up in Rockford, Illinois, studied at Williams College, and began performing comedy in the Chicago scene. She has written for *The Onion, New York Magazine,* and *Variety,* and the series *Alabama Jackson* for Adult Swim. She has performed across the country and hosts the monthly live show *High Gear Comedy* in LA. She is the host of *TV I Say with Ashley Ray,* a popular podcast and newsletter covering all things pop culture.

STAFF RECOMMENDATION: Ashley's comedic takedown of Shaun King is something to behold. Dangerously funny and eye-opening!

Rachel Kaly

RACHEL KALY (she/her)
is a comedian and writer based in New York.
She has written for *Clickhole*, *Irony Point*,
and Comedy Central. She hosts the live
shows *Major LOL Vibes* at Union Hall, and
previously hosted *Rachie's Awesomesauce
Advice Hour* and *Ellen is the Only Ally*. She
appeared on *High Maintenance*, *Vice Live*,
and impersonated Ellen DeGeneres on *The
Special Without Brett Davis*. Rachel's stand-
up and sketch videos satirize the comedy
scene, local politics, and commodification of
the queer community.

STAFF RECOMMENDATION:
Definitely watch Rachel's super funny
standup set at the live show *Butterboy* in
2019. She masterfully weaves reality and
fiction into stories about dating in New
York and coming out to her family. Also, her
website is an absolute gem.

Jamie Loftus

JAMIE LOFTUS (she/her) is a podcast host, comedian, and writer based in Los Angeles. After working at *The Boston Globe*, she pivoted to comedy and began creating absurdist, experimental performances. Her solo show *Boss, Whom is Girl* debuted at Lyric Hyperion and ran at the 2019 Edinburgh Fringe Festival. She has created digital video shorts for Paste and Comedy Central, and has written for *Robot Chicken*, *Super Deluxe*, and *Magical Girl Friendship Squad*. Jamie has created and released several podcast series, including *My Year in Mensa*, *Lolita Podcast*, and *Aack Cast*. She co-hosts the popular pop culture podcast, *The Bechdel Cast*, with comedian Caitlin Durante. She is currently producing her new hot dog themed solo show *Mrs. Joseph Chestnut, America USA* at the Elysian Theater, and a new supernatural themed podcast titled *Ghost Church*.

STAFF RECOMMENDATION:
Jamie's podcast series are incredible deep dives into niche topics. My favorite, *Aack Cast*, explores the world of the iconic comic strip Cathy and interviews contemporary comic artists and graphic novelists influenced by Cathy Guisewite, including myself! Jamie's podcasts are insightful, layered, and of course, really funny.

River Butcher

RIVER BUTCHER (he/they) is a stand-up comedian, writer, and actor based in Los Angeles. He started his career in improv comedy at Second City in Chicago and debuted his stand-up on *Conan* in 2016. They co-created the web series *Take My Wife* and live show *Put Your Hands Together* with comedian Cameron Esposito. They have appeared in *Good Trouble*, *Adam Ruins Everything*, and *Friendsgiving*, and voice acted for *Kipo and the Age of Wonderbeasts*. He currently hosts the baseball themed podcast *Three Swings*, and he just released his 2022 stand-up special, *A Different Kind of Dude*.

STAFF RECOMMENDATION:
River's new special *A Different Kind of Dude* is a great introduction to their thought-provoking sense of humor. They joke candidly about divorce and their gender journey.

Phoebe Robinson

PHOEBE ROBINSON (she/her) is an author, comedian, and actor based in New York. She was raised in Bedford Heights and studied screenwriting at Pratt Institute. She began her career in writing for *Girl Code*, *Broad City*, and *Portlandia*. She created her first podcast, *Sooo Many White Guys*, in 2016 and later co-created the podcast turned HBO series, *2 Dope Queens*, with Jessica Williams. She has written three bestselling books and founded the production company *Tiny Reparations*. She currently produces and hosts the talk show *Doing the Most* with Phoebe Robinson. Her most recent stand-up special *Sorry, Harriet Tubman* aired in 2021.

STAFF RECOMMENDATION:

I absolutely loved the series *2 Dope Queens*, and thought the show was an extravaganza of fun interviews, gorgeous looks, and great comedy. Phoebe is a fantastic entertainer and co-host! Special guests include John Early, Tituss Burgess, and Lizzo.

Sabrina Jalees

SABRINA JALEES (she/her) is a Canadian comedian, actor, and television personality based in New York. She was raised in Toronto and studied media arts at Ryerson University. She has appeared in numerous television series, including *Carol's Second Act*, *Flashpoint*, and *Baroness Von Sketch Show*. She has been a panelist on *Video on Trial*, *Match Game*, and *The Nightly Show with Larry Wilmore*, and she is a judge on *Roast Battle Canada* and guest judge on *Canada's Drag Race*. She writes for *Big Mouth*, *Powerless*, and *Search Party*, and in 2018 her half-hour stand-up special debuted on Netflix's *The Comedy Lineup*. Sabrina is currently creating the television series *Landing*, inspired by her experiences navigating the Brooklyn queer scene. She will be starring in the upcoming film *Brooke and Sam*, directed by Ally Pankiw.

STAFF RECOMMENDATION:
I had the privilege of seeing Sabrina perform at Lyric Hyperion in 2018. Definitely watch her joke about her Pakistani-Canadian upbringing and queer identity on *The Comedy Lineup*, and see her perform live at a show near you!

Jackie Keliiaa

JACKIE KELIIAA (she/her) is a stand-up comedian and writer based in Oakland. She was raised in Hayward, California and performs in venues around the East Bay. She organized virtual comedy shows during quarantine called *Good Medicine*, which fundraised for Indigenous communities. She performed standup for the series *First Nation Comedy Experience* and recently pitched an Indigenous-focused comedy festival at Yes, And... Laughter Lab 2021. Jackie co-produces and hosts *Amazonians*, a live comedy showcase of women comics, and currently hosts the podcast *The Jackie Show*.

STAFF RECOMMENDATION:
Jackie is a super funny and charming host of her podcast, *The Jackie Show*. I also recommend seeing her perform live if you happen to be in the East Bay!

Dulcé Sloan

DULCÉ SLOAN (she/her) is a stand-up comedian and actor based in New York. She grew up in Miami and Atlanta and studied acting at Brenau University. She has been named a "Comic to Watch" by *Variety* in 2018 and *Rolling Stone* in 2017. She performed on *Conan*, *Late Night with Seth Meyers*, and *Lights Out with David Spade*. Since 2017, she has been a beloved correspondent on *The Daily Show*. In 2019, her comedy special debuted as an episode of *Comedy Central Stand-Up Presents*, and she acted in the 2020 comedy *Chick Fight* and voice acted for *The Great North*. Dulcé appeared in the ensemble comedy special *Yearly Departed* for Amazon, and made headlines as a commentator for CNN's New Year's broadcast when she said her 2022 resolution was "No More Broke Dick!" She will be a guest judge on the upcoming season of *RuPaul's Drag Race*.

STAFF RECOMMENDATION:
Dulcé is beyond funny in her 2019 standup set for Comedy Central. She roasts NYC and LA, and talks candidly about her biological clock. Plus, she's currently on tour so go see her perform at a venue near you!

Meg Indurti

MEG INDURTI (she/her)
is a stand-up comedian and writer based in Los Angeles. She has written for several publications including *The New Yorker*, *Reductress*, *The Onion* and *The Hard Times*. She was selected as a StandUp NBC Semi-Finalist in 2017 and performed at San Francisco Sketchfest, Boston Comedy Festival, and Desi Comedy Fest.

STAFF RECOMMENDATION:
Meg's relatable humor is on full display on Tiktok. She makes hilarious videos about US politics, dating, and mental health. If you're in LA, go see her perform live at numerous popular venues!

Maria Bamford

MARIA BAMFORD (she/her) is a stand-up comedian, actor, and writer based in Los Angeles. She was raised in Duluth, Michigan and began performing stand-up as a student at the University of Minnesota. She has released almost 10 comedy albums in her career and her most recent one, *Weakness is My Brand*, has received critical acclaim. She has appeared in numerous shows like *Everything's Gonna Be Okay* and *Fresh Off the Boat*, and has voice acted for *Bojack Horseman*, *Big Mouth*, and *Summer Camp Island*. Maria has produced and starred in several projects, including *The Maria Bamford Show*, *Ask My Mom*, and the fan-favorite *Lady Dynamite*. She is currently on an international tour performing at festivals and venues around the world.

STAFF RECOMMENDATION:

I absolutely *The Special Special Special*, Maria's 2012 comedy special performed in front of her parents at home. *Lady Dynamite* is also a fantastic glimpse into her chaotic, hilarious, and wonderful mind.

Maysoon Zayid

MAYSOON ZAYID (she/her) is a stand-up comedian and actor based in New York, raised in New Jersey. She started her career in television by appearing in *As the World Turns* and *Law & Order*, but after feeling excluded by the limited roles available to her in the entertainment industry, she pivoted to stand-up and co-founded the New York Arab-American Comedy Festival in 2003. She debuted her one-woman show *Little American Whore* in 2006 at the Comedy Central stage. She was featured in the documentary, *The Muslims Are Coming!*, in 2013, and has been profiled by *The Hollywood Reporter* and *NPR*. Her acclaimed and popular TED Talk "I Got 99 Problems... Palsy Is Just One" debuted in 2014. She is currently a recurring character on *General Hospital* and hosts the docuseries *DisCo*, co-created with filmmaker Nicole Newnham.

STAFF RECOMMENDATION:

Maysoon's TED Talk is necessary viewing for everyone. "I Got 99 Problems... Palsy Is Just One" is an incredible 15 minute set addressing ableism in her personal and professional life, with a healthy dose of hard-hitting jokes.

Jourdain Searles

JOURDAIN SEARLES (she/her) is a writer and stand-up comedian based in Brooklyn. She was raised in Augusta, Georgia and studied writing at NYU's Tisch School of the Arts. She has written for numerous publications including *The New York Times*, *The Hollywood Reporter*, and *Vanity Fair*. She previously hosted the live show *Madams of the Universe* and has performed at comedy festivals around the country, like *Bad B*tch Revolution Fest*, *Reel Love Film Fest*, and more. She co-hosts the weekly pop culture podcast *Bad Romance Podcast* with Bronwyn Isaac.

STAFF RECOMMENDATION:

As a huge rom-com fan, I must recommend *Bad Romance Podcast!* Jourdain and Bronwyn dissect the best and worst movies in the genre with a healthy dose of humor. Special guests include comedians Dana Donnelly, George Civeris, and Taylor Garron.

Rose Matafeo

ROSE MATAFEO (she/her)
is an actor, comedian, writer, and filmmaker from Auckland. She made a name for herself in the comedy world at just 15 years old by performing at the New Zealand International Comedy Festival. From 2010-2014, she produced solo stand-up comedy shows at the festival, including *The Rose Matafeo Variety Hour* for which she won the Billy T Award in 2013. In 2015, she performed with comedian Guy Montgomery at the Edinburgh Festival Fringe, and in 2018 she won Best Show at the festival. She was the first person of color and New Zealander to win that award. Rose has an illustrious film and television career, including creating and starring in the New Zealand sketch show *Funny Girls*, and the series *Starstruck* produced by BBC and HBO Max. She directed the series *Golden Boy*, and starred in the Taika Waititi-produced film *Baby Done*. Her latest special *Horndog* was released on HBO Max in 2020.

STAFF RECOMMENDATION:
As a connoisseur of romantic comedies, I'm an avid fan of Rose's charming and funny show *Starstruck*. She's also one of the best contestants to play the ridiculous games on *Taskmaster*.

LIVE SHOWS / VENUES

Valley Girl - Hosted by Katrina Davis
Junior High - LA

Dynasty Tonight!
Dynasty Typewriter - LA

Witch Hunt - Hosted by Merrill Davis
Lyric Hyperion - LA

Icons Only - Hosted by Nori Reed, Maddie Connors, & Christina Medrano
Extra - Hosted by Danielle Perez
Silverlake Lounge - LA

Weirdo Night - Hosted by Dynasty Handbag
Zebulon - LA

Playspace - Open Mic
Funny Games - Hosted by Kate O'Connor & Jo Scott - Open Mic
Big Wig - Hosted by Caleb Hearon & Brian Robert Jones
The Elysian - LA

Hot Tub - Hosted by Kurt Braunohler & Kristen Schaal
The Virgil - LA

Atsuko & Friends - Hosted by Atsuko Okatsuka
The Largo - LA

Hot Gear Comedy - Hosted by Ashley Ray & Babs Gray
The Airliner - LA

Tea Before Bed
Brooklyn Comedy Collective - NYC

Not Dead Yet - Hosted by Ana Fabrega, Amy Silverman, & River L Ramirez
Major LOL Vibes - Hosted by Rachel Kaly
Good Show - Hosted by Lili Michelle, Yedoye Travis, & Conner McNutt
The Lesbian Agenda - Hosted by Sophie Santos
Union Hall - NYC

Peaches & Cream - Hosted by Lili Michelle & Joey Dardano
Central Organic - NYC

Mary Beth & Friends - Hosted by Mary Beth Barone
The Bell House - NYC

The Slipper Room - NYC

Asylum - NYC

Club Cumming - NYC

Good Medicine
Oakland

Amazonians
San Francisco/Oakland

COMEDY FESTIVALS

Just For Laughs SF Sketchfest

Netflix is a Joke All Jane Comedy Festival

Clusterfest Yes, And Laughter Lab

Brooklyn Comedy Festival

SOPHIA ZARDERS (she/they) is an illustrator, visual artist, and pop culture queen. They are from Long Beach, California and currently based in Vancouver, British Columbia to pursue an MFA from Emily Carr University of Art & Design. Their illustrations have been published in *The Nation, Razorcake, Fiyah Literary Magazine,* and by HarperCollins. Sophia has been commissioned by grassroots organizations across the country, including the Ella Baker Center for Human Rights, Forward Together, SaveArtSpace, and Good Trouble. They have exhibited at Somos Gallery in Berlin, Haight Street Art Center in San Francisco, and ShockBoxx Gallery in Manhattan Beach. Sophia's research & art practice point to cinema, humor, history, drag, feminism, and representation.